robert lazzarini

John B. Ravenal

Virginia Museum of Fine Arts
Richmond

This book was published on the occasion of the exhibition *robert lazzarini* at the Virginia Museum of Fine Arts, October 25, 2003 – January 4, 2004.

Library of Congress Cataloging-in-Publication Data
Lazzarini, Robert.
 robert lazzarini / John B. Ravenal.
 p. cm.
 "Published on the occasion of the exhibition 'robert lazzarini' at the Virginia Museum of Fine Arts, October 25, 2003 – January 4, 2004." Includes bibliographical references and index.
 ISBN 0-917046-66-8
 1.Lazzarini, Robert – Exhibitions. 2. Sculpture, American – 20th century – Exhibitions. 3. Installations (Art) – United States – Exhibitions. I. Ravenal, John B., 1959 – II. Virginia Museum of Fine Arts. III. Title.
 N6537.L395A4 2003
 709'.2 – dc21 2003013213

ISBN 0-917046-66-8

Produced by the Office of Publications
Virginia Museum of Fine Arts
2800 Grove Avenue, Richmond, VA 23221-2466 USA
Distributed by the University of Virginia Press

Graphic Designers: Robert Lazzarini and Sarah Lavicka
Editor: Rosalie West
Editorial Assistance and Indexers: Anne Adkins and Ginger Cofield
Photography: Jeffrey Chong. © 2003 Robert Lazzarini
Composed in Perpetua by Sarah Lavicka in QuarkXPress
Printed in Belgium by Snoeck-Ducaju & Zoon on acid-free 150 gsm Magnomatt text

FRONT AND BACK COVERS: *skull (i)*, 2000, resin, bone, and pigment, 10 x 9 x 6 inches.

CONTENTS

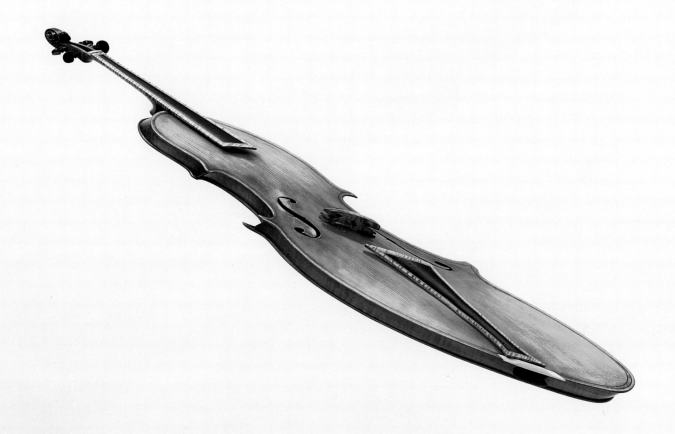

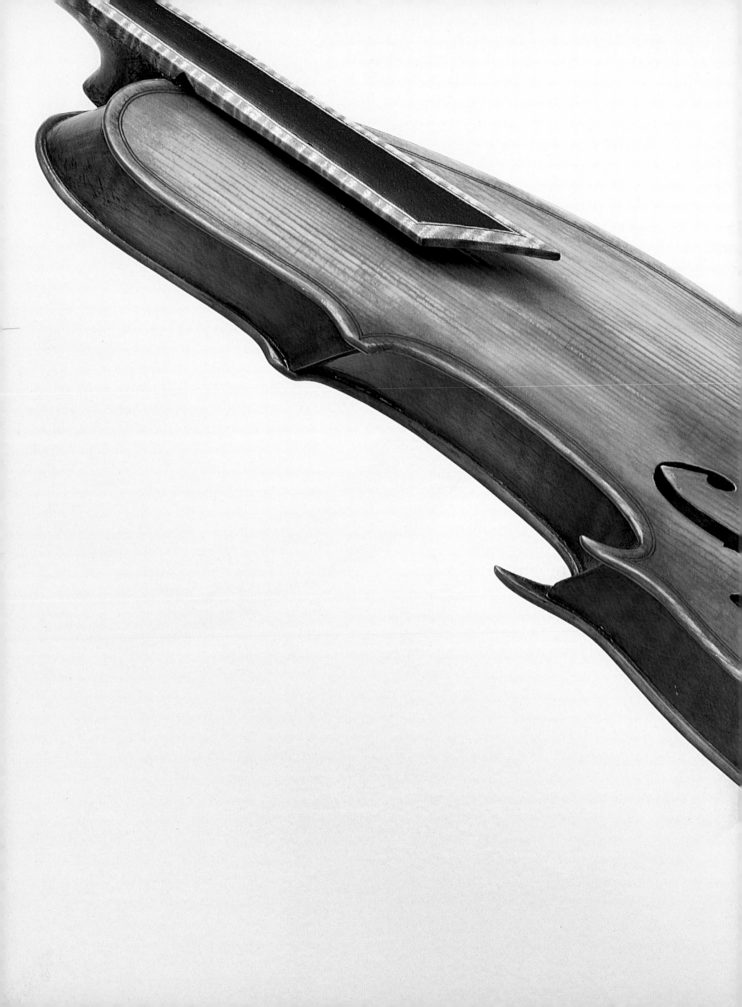

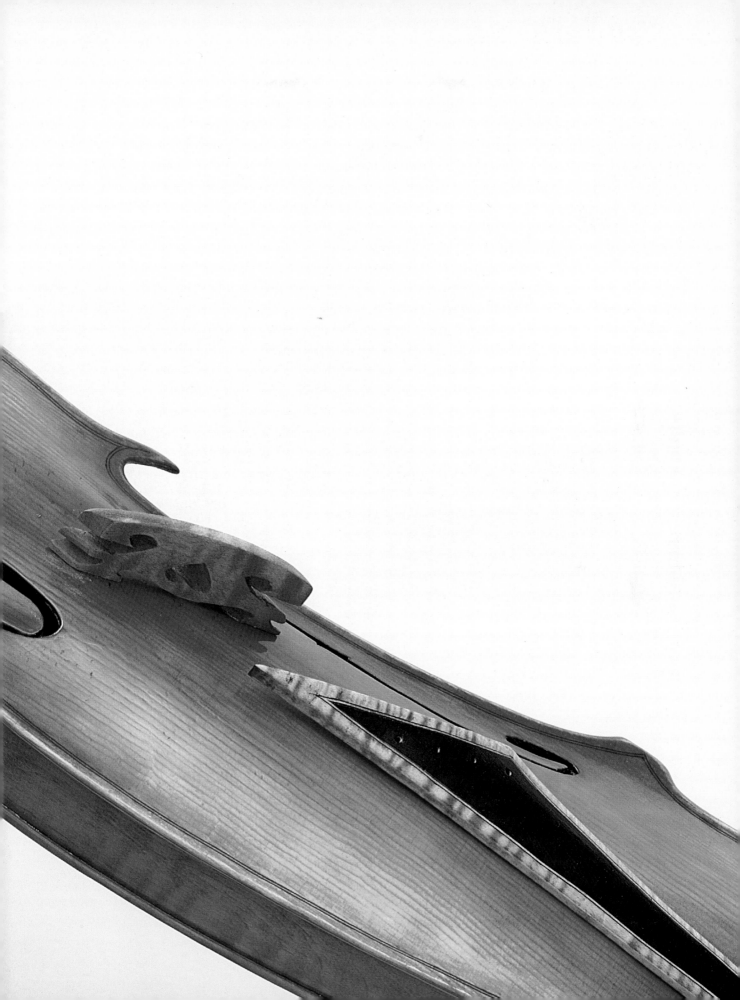

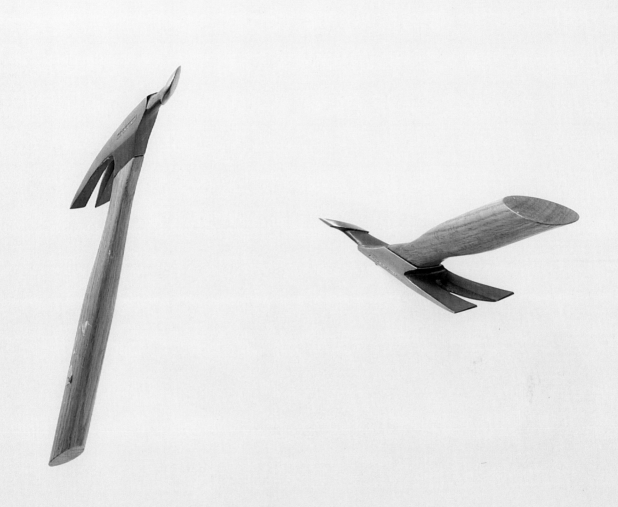

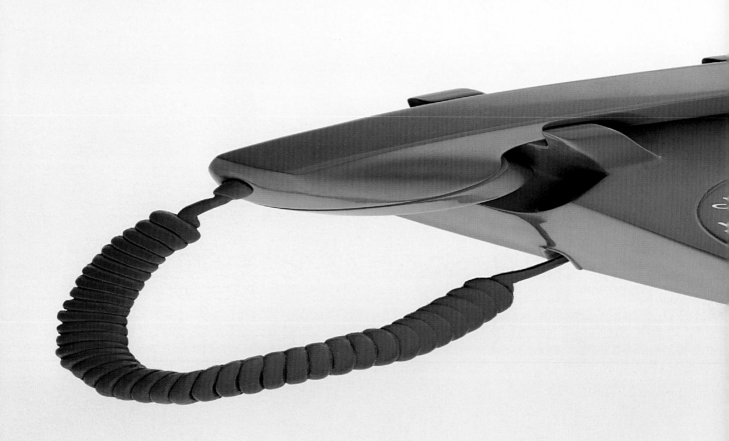

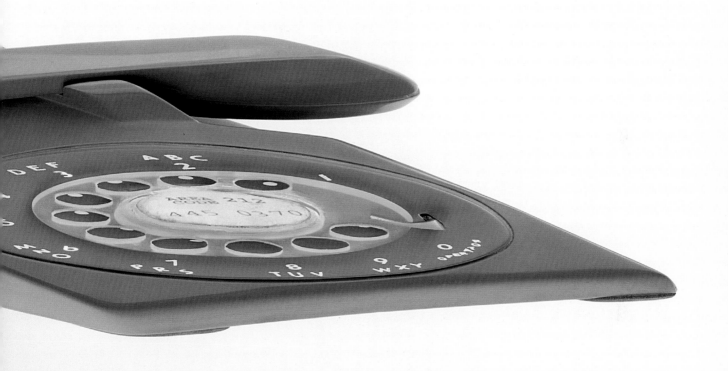

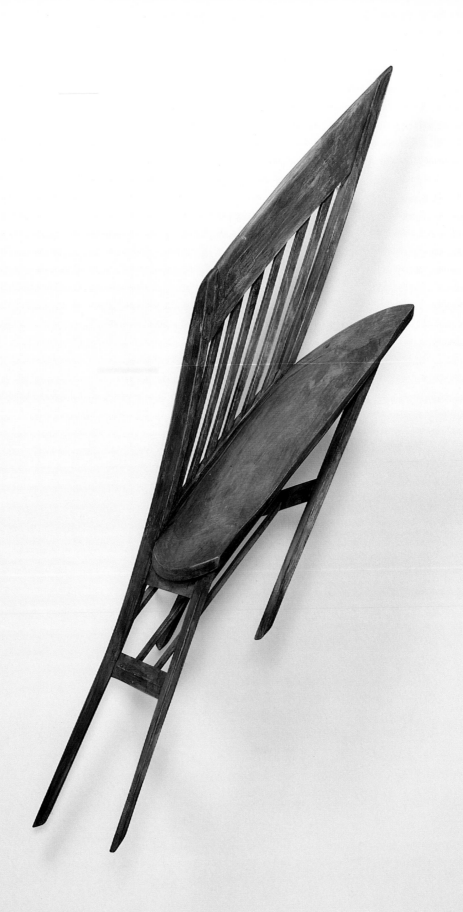

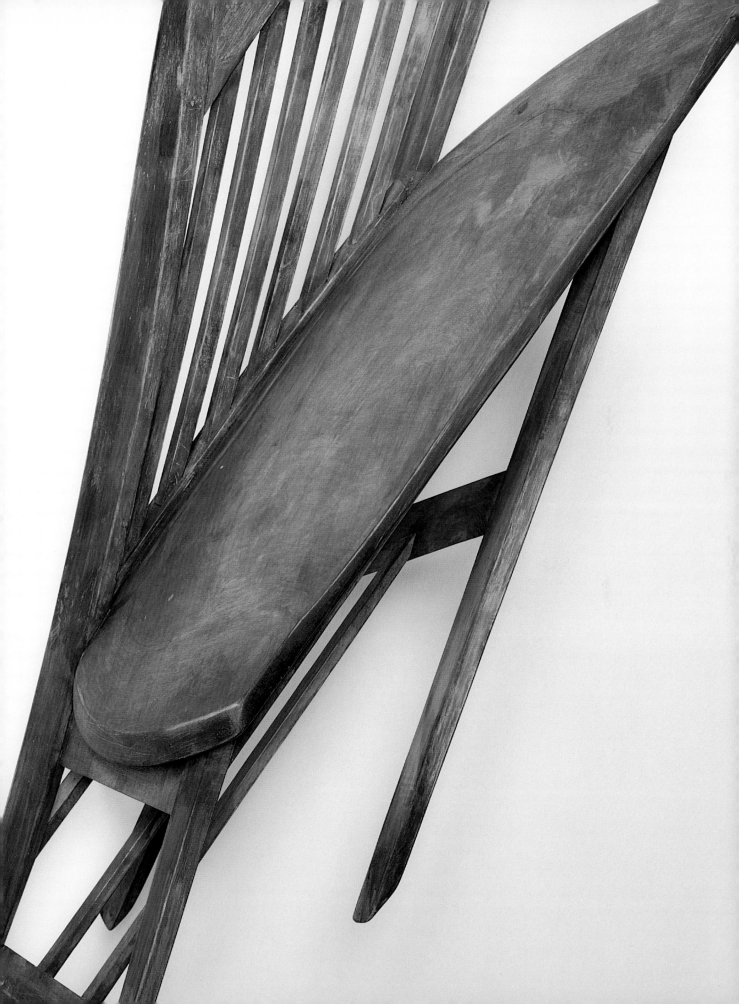

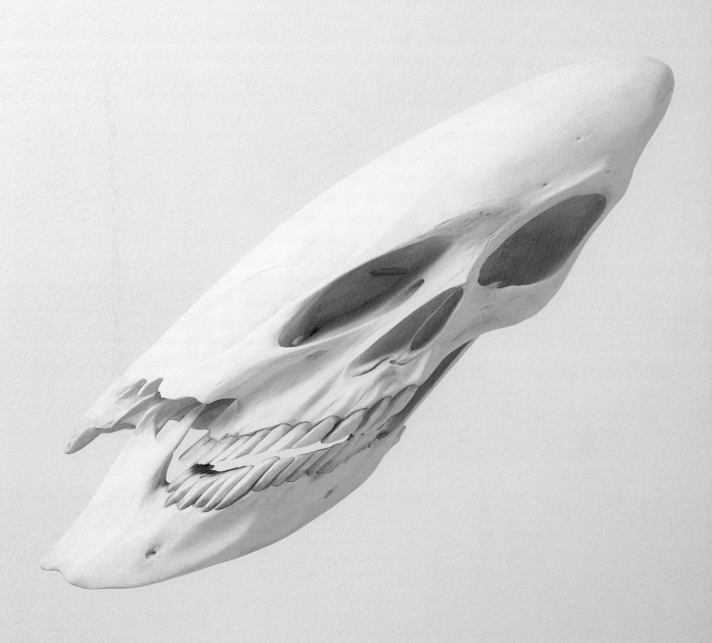

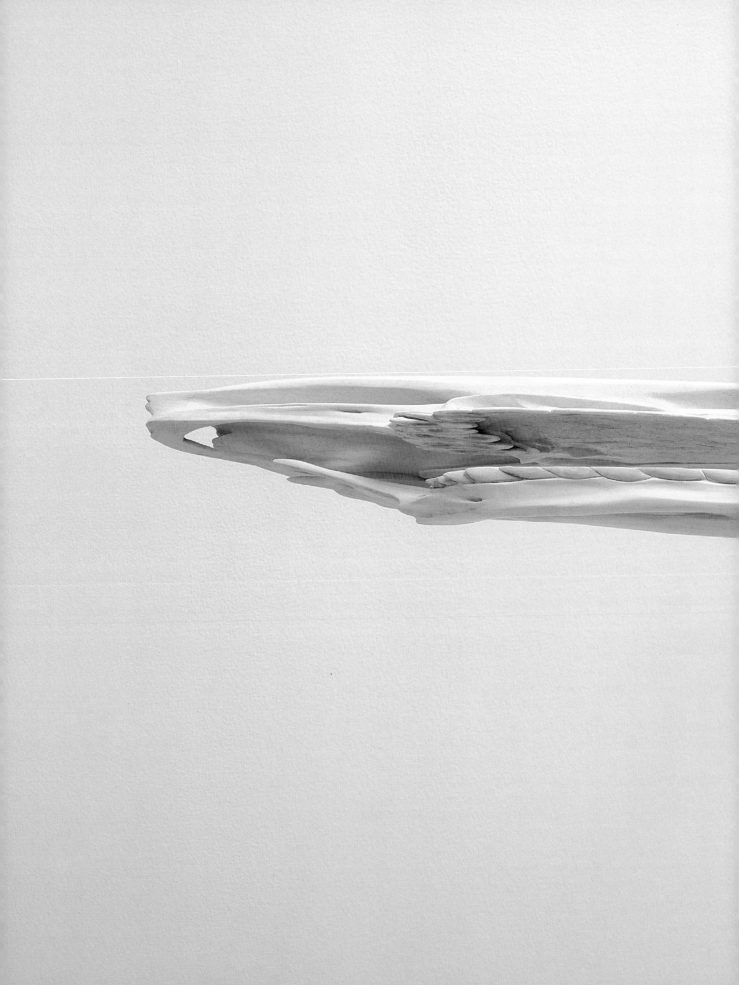

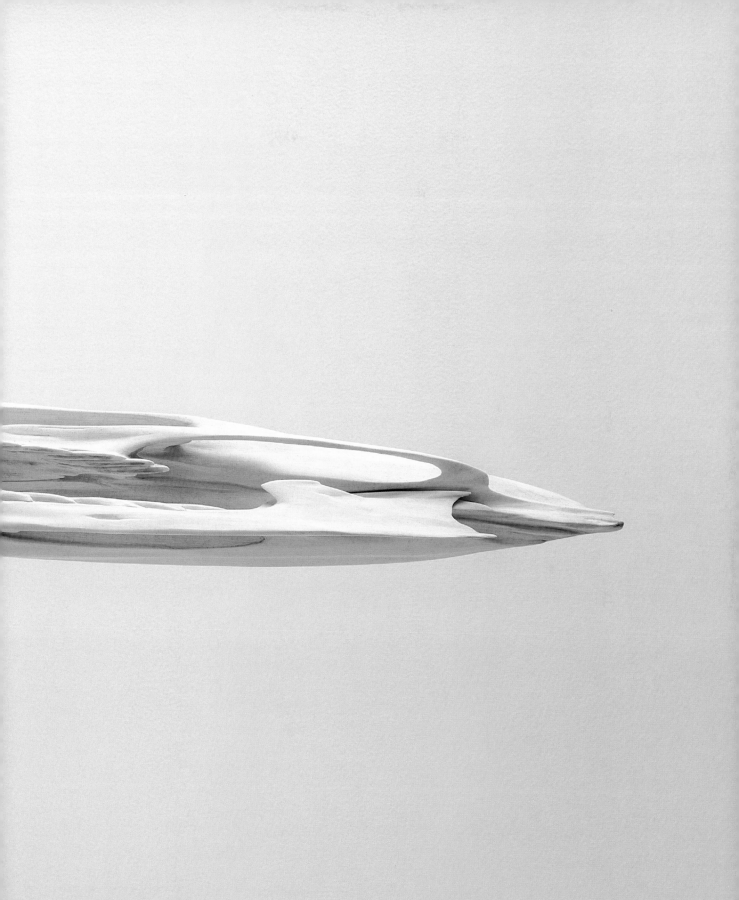

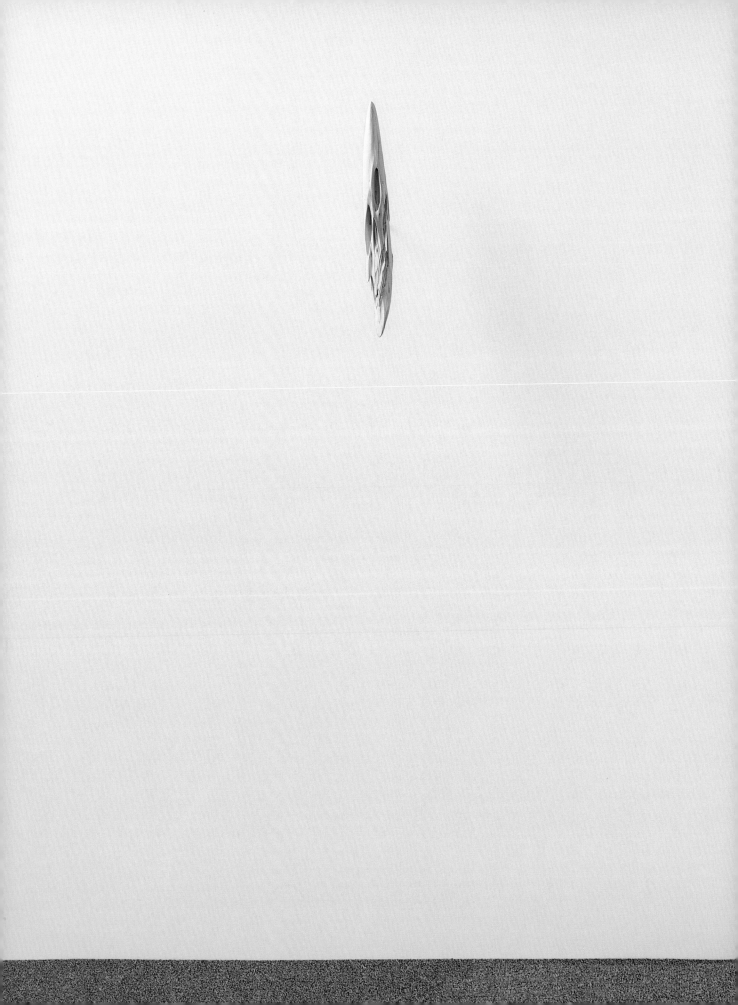

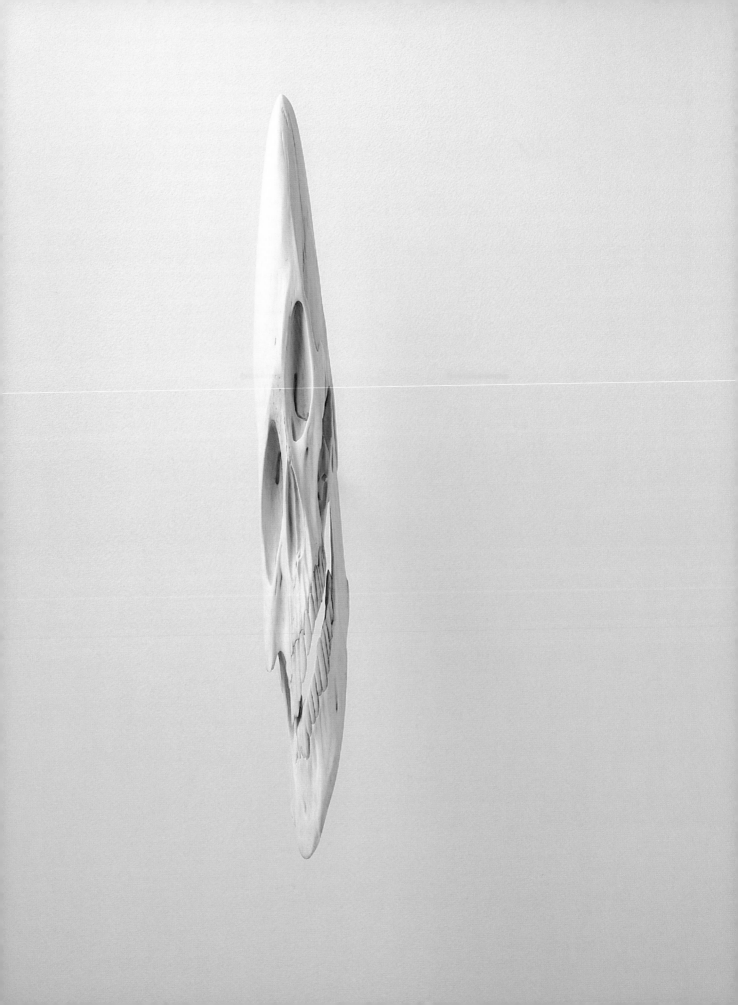

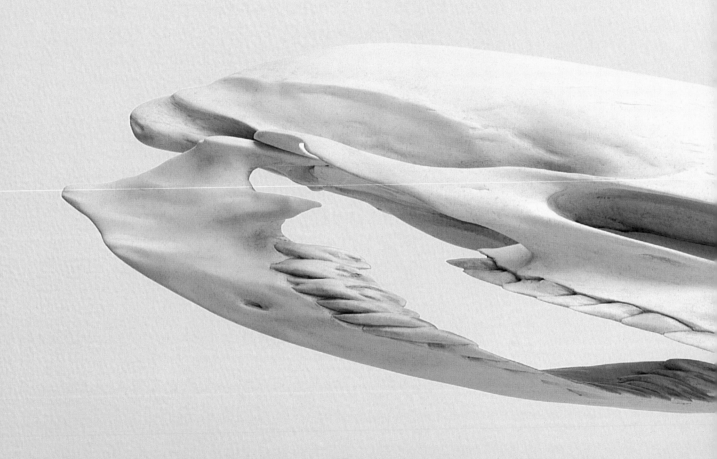

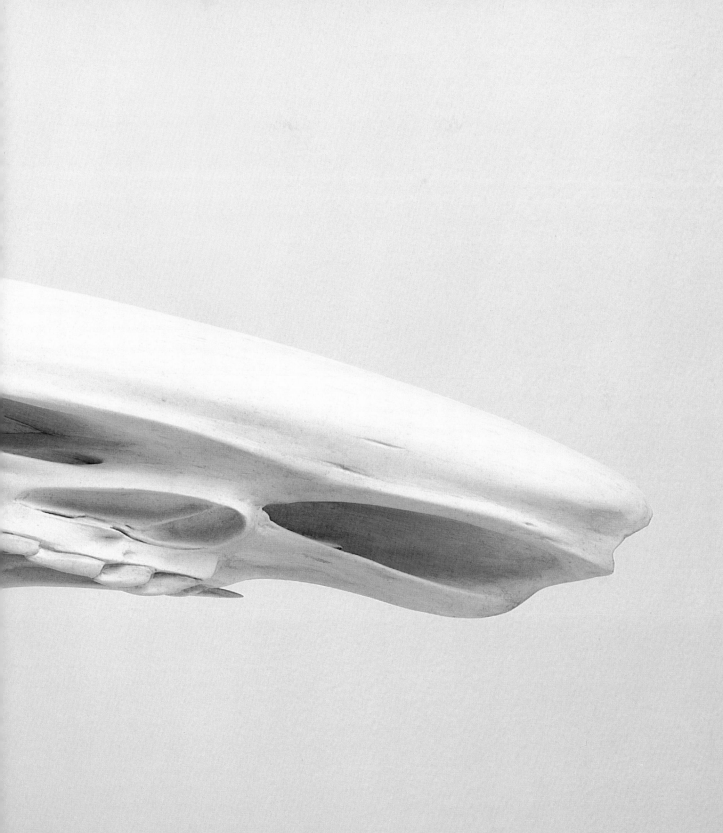

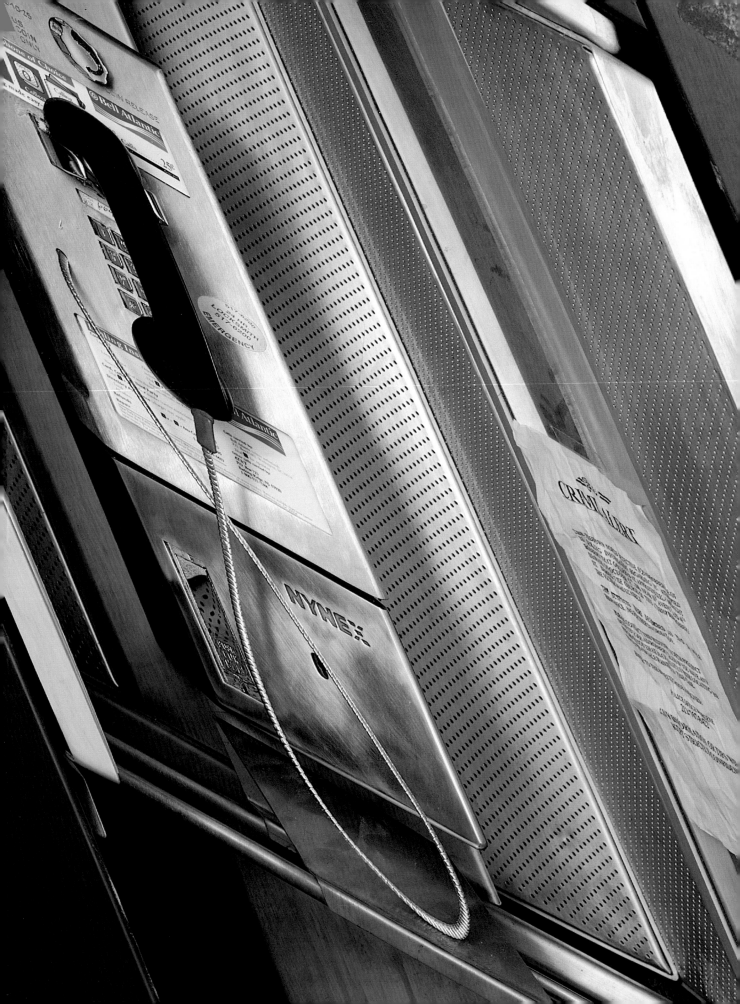

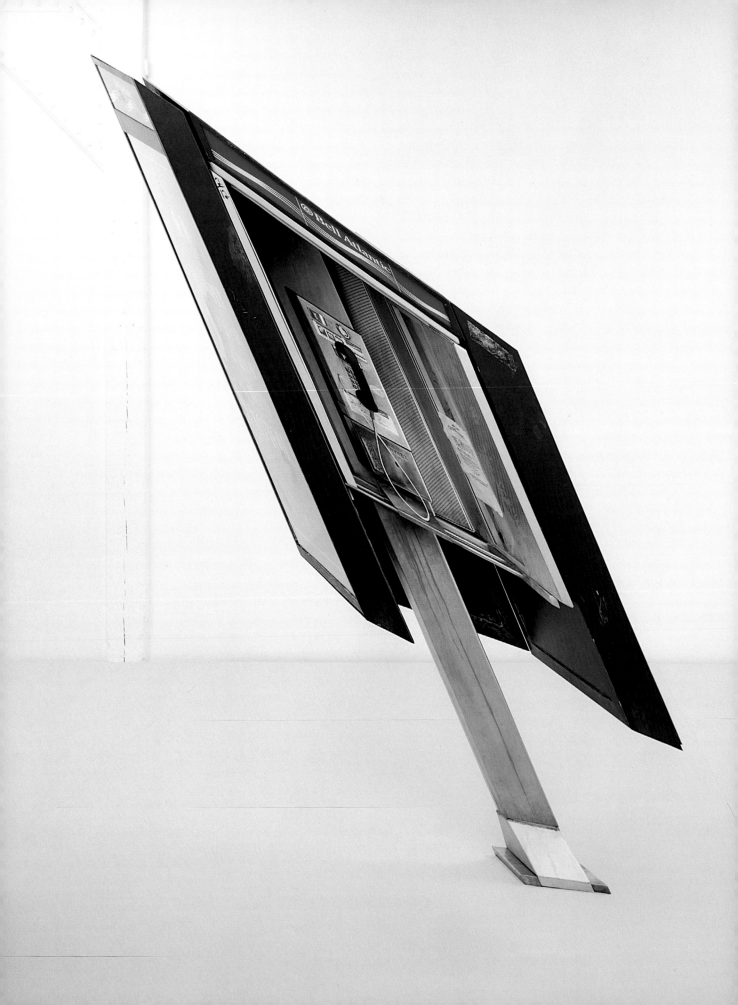

"objects slipping toward their own demise"

Robert Lazzarini's sculptures are at once rigorously formal and intensely expressive. As distorted versions of familiar objects, they appear in the process of slipping—from three to two dimensions, from realism to abstraction, from this world to the next.[1] One of the paradoxes of Lazzarini's work is that by confronting the viewer in a direct, uncompromising manner, his objects yield a contemplative space in which the temporality of life and the transience of all things make themselves known. Products of a dense and innovative process, his works seem both real and unreal: their striking immediacy is belied by a quality of ghostliness, as if they were hardly there at all.

Lazzarini's interest in the play between real and unreal began with his early art training. As a child, he learned to draw by copying from old-master art books. He recalls being fascinated by the differences among illustrations of the same work. Lazzarini's experience studying and copying these reproductions gave him an intimate relationship with the images of art history, forming an initial and lasting part of his mental reservoir. At the same time, it stirred in him an interest in the discrepancies between the image and the actual thing that informs his work today.

During the mid 1980s, Lazzarini's facility in drawing led him to the Parsons School of Design and then to the School of Visual Arts, both in New York, but he decided to stretch himself by majoring in sculpture. This choice reflected his

decision to focus on the object, something that occupies real space, as opposed to the illusionism of painting. Lazzarini's decision to make sculpture must also be seen in light of the personal importance he assigned to the physical object—its embeddedness in the world appealed to him as a metaphorical hedge against the passage of time. Nonetheless, he would repeatedly set up the qualities of solidity and permanence as foils for a heightened awareness of mortality and decay.

After graduating from art school, Lazzarini took a job near the Metropolitan Museum of Art, which he visited frequently at lunch to study different sections of the collection by drawing, taking notes, and making clay models. (The Met had already been an early home away from home: he spent many days there as a child drawing arms and armor and other objects.) In the early 1990s, Lazzarini began taking graduate art history classes at New York University's Institute of Fine Arts and working in the Met's bookstore. This job, which lasted for nearly five years, afforded him continued easy access to the museum's collection.

To understand more fully the stylistic vocabularies he was studying, Lazzarini began breaking down his clay models, distorting them, and recombining their parts. After casting the new forms in plaster, he would shoot slides of them. Further experimentation led him to project the slides at oblique angles, producing additional distortions from which he made graphite drawings. The finished drawings were never directly from

the object, but mediated by the clay and plaster models and the projected slides. By the mid 1990s, then, many of the key elements of his mature work had come together: distortion, the re-creation of found objects as subject matter, and a multi-staged process combining sculpture, drawing, and photography. But Lazzarini was dissatisfied with his sculptural material, considering plaster to be dated and conservative. The breakthrough came at the Met while he was studying a sixteenth-century fencing jacket made with silver and gold yarns.[2] He realized that he could use the actual materials of whatever object he would base his work on: greater truth to the original would ground his distortions in a more solid foundation of reality.

Lazzarini's interest in distortion, then, is closely linked to his development of a unique creative process, to his study of historical art, and to his search for an expressive device that could suggest his fascination with what lies beyond representation. This drive to address the unsayable led him to see the necessity of wedding distortion to realism. In this way he could make sure that viewers understood his objects as part of real life, not dream images. At the same time, he could address that which hovers invisibly around the real and, for an acute consciousness, imbues all of life. If this sounds like a romantic notion, Lazzarini would be the first to agree.

process

Given Lazzarini's strong attachment to the Met, it is not surprising that his first mature sculpture took as its subject a 1693 Stradivarius violin from the museum's collection.[3] For Lazzarini, this sculpture (pages 4–7) crystallized the procedure for his future production: choose a found object,

scan a photograph of it into the computer, and manipulate the image digitally to introduce extreme distortions; then rebuild the object to scale in its original materials, incorporating the seemingly impossible geometries and working with collaborators when necessary during the fabrication (in this case a violin maker).

Soon after, Lazzarini refined his approach to digital technology: in subsequent works, after exhausting the possibilities of two-dimensional manipulation in Photoshop, he applied the distortions to a virtual three-dimensional model that he built with CAD (computer-aided design).[4] Next, the virtual model would be returned to an actual object by means of "rapid prototyping": computer-generated model making in which a manufacturer converts the CAD file to a quickly built form, often made of laser-cut layers of paper, nylon, polyester, or thermoplastic.[5] Because Lazzarini's interest is in the original object, however, and not in the vocabulary of computer processes, he goes to great lengths to distance his objects from signs of digital and mechanical production (unlike some artists who incorporate the appearance of computer and rapid-prototyping vocabularies in their finished work[6]). With *skulls* (pages 16–25), for example, Lazzarini worked on the prototypes to remove the signs of lamination and laser cutting, and then surrounded them with silicone rubber to make a mold in which he cast a plastic positive. He then further worked the plastic object, carving and sanding to eliminate all remaining traces of the prototyping process.

The final object is cast in a second, master mold, using materials that are as close as possible to the original found object. Lazzarini cast *skulls*

in pulverized animal bone with a resin binder. He cast *phone* (pages 10–11) in colored plastic (a plastics company computer-matched the mouthpiece from his actual studio phone and sent him a tinted suspension to mix with the epoxy resin and hardener).[7] His *chair* (pages 12–15) was closer to *violin,* requiring joinery and bonding to assemble the twenty-one different carved wood parts. Lazzarini's tour de force, *payphone* (pages 26–29), involved forty-five collaborators with expertise in various areas of industrial fabrication.

Before the object is complete, Lazzarini does additional carving, coloring, and patinating. Once *skulls* were cast, he worked the bone objects with rasps, rifflers, files, and finishing sandpaper to make their resemblance to human anatomy as convincing as possible. Lazzarini's facility with carving and his drive to capture the details of both structure and surface reflect his interest in past zeniths of sculptural realism, especially from the Hellenistic era and Second Empire France[8]—periods some two millennia apart in which artists routinely transformed stone into apparitions of living flesh. Lazzarini's attention to even the final layer of finish continues his commitment to achieving a heightened level of authenticity: after buffing *phone* to a high polish in imitation of its industrially produced model, he scuffed and dirtied it to create the appearance of use; *skulls* involved extensive hand coloring to create a convincing appearance of age, making them as much three-dimensional paintings as sculpture.

Lazzarini refers to the computer as an "extremely sharp pencil," although its impact on his work extends beyond a merely utilitarian role. Photoshop informs his vocabulary by systematizing and clarifying the geometric distortions with which he works. (In geometric distortion—unlike the biomorphic distortion Salvador Dali used to create his famous soft watches—the parts change in consistent relation to the whole, making possible the union of extreme realism and extreme distortion.) In addition, Photoshop allows Lazzarini to apply multiple, or compound, distortions, a central feature of his work. By contrast, an example of single distortion, familiar from the elongated skull in the foreground of Hans Holbein the Younger's famous painting *The Ambassadors* (page 34), is anamorphism.[9] The object is stretched along the single axis of linear perspective and its recession accelerated more rapidly than the remainder of the image. Viewers can return the anamorph to a normal image by assuming a position flush with the upper right edge of the canvas (or of the page, if viewing a reproduction) and looking across the surface of the work at an extremely acute angle.[10] The baffling smudge will then collapse into a recognizable skull.

Lazzarini's objects, however, never return to a normal form, no matter what angle they are seen from. Pulled in multiple directions simultaneously and according to various rules, they expand and contract as one moves around them, offering a spectrum of unexpected views that continually defy vision—refusing, as it were, to succumb to our visual mastery. This appearance of continual motion and resistance to resolution creates a spatial paradox. Different laws of physics seem to apply to the object and the surrounding room, creating vertigo-inducing optical effects.

Although hand drawing no longer figures as a part of Lazzarini's sculptural process (he does,

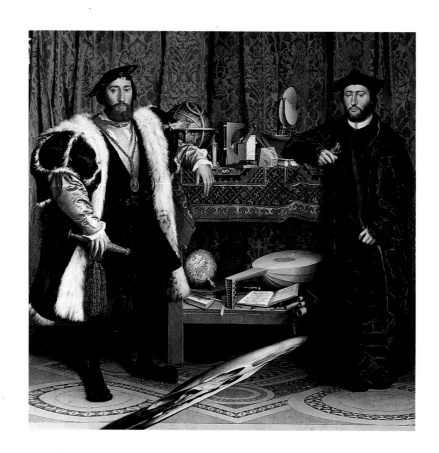

Hans Holbein the Younger (German, 1497/98–1543)

Jean de Dinteville and Georges de Selve (The Ambassadors), 1533, oil on wood

81 ½ x 82 ½ inches (207 x 209.5 cm)

© The National Gallery, London

however, make finished drawings), his Photoshop manipulation of the two-dimensional image retains the concept of drawing as a central part of his work. Lazzarini is interested in the object as a mark or gesture, and his initial choice of object, and of the view he will use on the computer, are driven as much by its two-dimensional "image quality" as by any other considerations. In this sense, the continuous shifting between two and three dimensions—between image and object—that a viewer experiences in front of his work is built in from the beginning.

By mounting his works on the wall, Lazzarini emphasizes the confrontation with the "iconic" image, as he refers to the frontal view, and underscores the way that his objects function as both two- and three-dimensional art. On the one hand, the wall becomes a field against which the form of the object is defined, in the same way that an irregularly shaped and evenly painted canvas by Ellsworth Kelly functions as a figure against the entire wall (in contrast to conventional painting, which functions as a self-contained space for its own figures). The relative smallness of Lazzarini's works floating on the expanse of wall further focuses attention on the figure/ground relationship. On the other hand, the object's three-dimensional cues prompt the viewer to move around it, in an effort to reconcile varying profiles seen over time into the experience of a complete whole.

Lazzarini's choice of diffused fluorescent lighting adds to the ambiguity between two and three dimensions by providing flat, even light that reduces shadows and minimizes the usual suggestions of volumetric form. Inconspicuous mounting devices that make the works appear to hover just in front of the wall further confuse an accurate reading of the work's location in space. Even the carefully considered choices of neutral flooring for various works—grey carpet for *skull* and grey painted plywood for *payphone*—help set a tone of heightened visual awareness.

realism

The result of Lazzarini's efforts is to drive his work toward extreme realism—a level of mimicry so faithful that viewers transcend, at least momentarily, their awareness of observing an illusion and believe they are beholding the actual thing. This passion for verisimilitude connects Lazzarini to contemporary sculptors as diverse as Robert Gober, Charles Ray, and Jeff Koons, all of whom work with various related notions of realism. Their ideas developed out of a theory-laden period that began in the mid 1980s when texts by French philosopher Jean Baudrillard gained widespread popularity among artists and critics. Subjecting the notion of the real to extensive redefinition, Baudrillard posited that the domination of life by mass media images and signs had created a realm of hyperreality in which simulations entirely replaced reality, so thoroughly had they subsumed the originals and substituted themselves.[11] Pre-Baudrillardian realism of the 1970s strove to convince viewers of its truthfulness, accepting the language of realism as authentic and legitimate. Proponents of this type of realism include illusionist sculptors Duane Hanson and John DeAndrea, whose highly detailed life-size figures presented three-dimensional counterparts to Photorealist paintings by Richard Estes, Robert Cottingham, and others. Realism now, however, is not so simple an affair; more deeply theorized than before, its every appearance calls into question its own authority.

Although aware of the complexities involved in the concept of the "real," Lazzarini's embrace of realism is sincere in its conviction that his masterfully simulated objects can re-create the texture of lived experience. His choice of a violin as the subject for his first mature sculpture reflects his roots in traditional notions of heightened illusionism—including nineteenth-century American trompe l'oeil and its close antecedent, seventeenth-century Dutch still life—which sought to imitate natural appearances so convincingly that viewers would momentarily mistake the objects depicted for the real thing.[12] Growing up, Lazzarini had in his home a reproduction of William Harnett's *The Old Violin* (page 37), an icon of American trompe l'oeil. It provided an example for Lazzarini not only in the careful rendering of every nuance of surface detail, but also in the depth of meaning that could be conveyed by a single familiar object, framed against the background of a wall or door.

Lazzarini considers all of his works to be still-life objects. Mostly human-made and made to be used (only the skulls are organic and nonutilitarian), they are familiar to us in an immediate, tactile way. Although a working instrument, the violin stands slightly apart from his later works by possessing an elevated status—a Stradivarius represents technical perfection in its class. But even here, the craftsman's virtuosity is subordinated to the object's function. Lazzarini's admiration for this approach is evident in the way he subordinates his own remarkable mastery of fabrication to the illusion of extreme realism.

Lazzarini quickly turned to more ordinary items in his next group of works, the *studio objects* (pages 8–15). The rotary phone is a single-line desk set that was the workhorse of Western Electric for decades. First produced in this version around 1954 and still made today by many of the companies to whom the design was licensed, the 500-series model is the phone most baby boomers grew up with.[13] The chair, resembling familiar stout school furniture, is solid wood and continues a somewhat unchanging line of late nineteenth- and early twentieth-century utilitarian design. The hammers are the classic wood-handled 16-ounce Stanley claw version. All are designed but anonymous, possessing a deliberate generic or archetypal quality that suggests they could as easily exist in a mid-Western rural setting from any time over the past fifty years as in a contemporary New York artist's studio. This range of associations underscores Lazzarini's attachment to a broadly defined notion of American realism.

As generic as they are, each of these objects also hints at autobiography. Modeled on things from his own workplace, the phone bears Lazzarini's old studio number on its face, the chair is based on the only place there for a visitor to sit, and the hammers replicate the signs of wear and tear from his own tools.[14] Together, this trio of still-life objects expresses something of Lazzarini's vision of the artist's life in the studio: their distortion suggests a level of intensity so great as to warp one's perception of ordinary forms, a hallucinatory experience provoked by prolonged isolation and relentless focus on the task at hand. Lazzarini's view of the studio as a place of sweat, suffering, and near psychosis—a not entirely unjustified though somewhat quixotic perspective in this age of "post-studio" art[15]—is no doubt amplified by the demanding nature of his process, with its many stages of design and production, exacting technical requirements, and

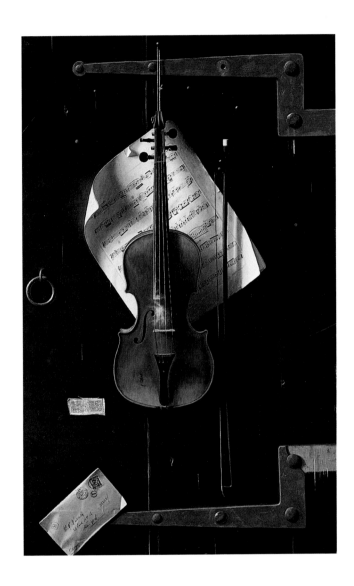

William Michael Harnett (American, 1848–1892)

The Old Violin, 1886, oil on canvas, 38 x 23 ⅝ inches (96.5 x 60 cm)

National Gallery of Art, Washington, D.C., Gift of Mr. and Mrs. Richard Mellon Scaife

in honor of Paul Mellon, 1993.15.1

Photo by Jose A. Naranjo

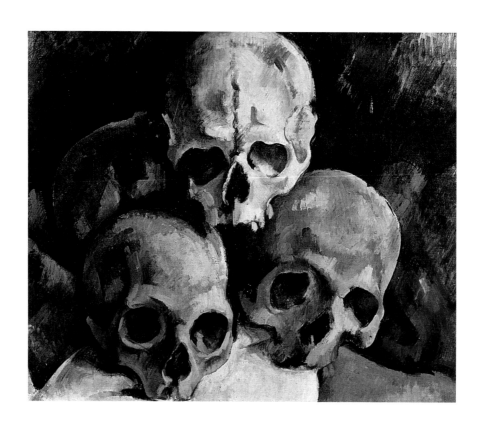

Paul Cézanne (French, 1839–1906)

Pyramid of Skulls, 1898–1900, oil on canvas

15 ³⁄₈ x 18 ³⁄₈ inches (39 x 46.5 cm)

Grand Palais, Paris/Bridgeman Art Library

hours of repetitive finishing work, all fueled by a drive toward perfection. This view also reflects Lazzarini's interest in the notion of artists—visual artists, writers, musicians—as perpetually confronting their demons through their work. Edgar Allan Poe, in his propensity to dig beneath the surface for psychological and emotional content and his frequent treatments of fear and madness as literary subjects, provides a particularly compelling model for Lazzarini. Poe's idea of being haunted by one's own work partly informed Lazzarini's decision to treat icons of the artist's studio as the subjects for ghostlike sculptural distortions.

Lazzarini's *skulls,* the series that followed *studio objects,* further builds on the use of symbolic objects in traditional still lifes. From the beginning of the seventeenth century, paintings often presented objects as emblems of life's pleasures and accomplishments and, simultaneously, as reminders of life's brevity. Called *vanitas* images, these painted scenes of overripe fruit, upended glasses, guttered candles, and musical instruments derived from classical and biblical passages describing the vanity of worldly achievement in the face of ultimate demise.[16] Skulls have played a particularly important role in these images; when placed beside objects representing worldly pleasure and achievement, they offer a starkly contrasting message.

While Lazzarini's *skulls* have often been seen as deriving from the distorted skull in Hans Holbein's *The Ambassadors,* their appearance in Lazzarini's work is the result of his interest in a broad range of historical art. In addition to images by *vanitas* masters such as Pieter Claesz, Lazzarini cites Cézanne's *Pyramid of Skulls* (page 38) as one

important part of his cumulative mental reservoir of ideas and inspiration. Cézanne presents his pile of skulls as symbols of mortality but also as darkly humorous objects. They are equivalents for the oranges and apples he often painted, as if to say that everything, whether fruit or human remains, is subordinated—not to death, as the concept of *vanitas* would have it—but to the artist's eye.

The *skulls* also reflect Lazzarini's interest in Andy Warhol. Warhol made a series of skull paintings in 1976, an overt nod to the *vanitas* tradition. Lazzarini acknowledges his interest in these works (and in Warhol's guns and knives, painted in 1981–82,[17] which may have partly inspired Lazzarini's decision to tackle these subjects, as well).[18] But Warhol's influence extends beyond the choice of specific motifs to a shared fascination with the way in which violence and death permeate every corner of American life, transforming mundane objects and images into icons dense with grisly associations. Lazzarini's use of repetition in the skulls and guns (each is a series of four variations on a theme) also recalls Warhol's extensive use of repetition and variation. *Orange Disaster #5* (page 40) is characteristic. Small accidents of the printing process introduce variations into the relentless repetition of the found image of an electric chair.

Lazzarini's *guns* (in production at the time of this publication), based on Smith & Wesson 38-caliber pistols, continue his exploration of still-life imagery overtly associated with death and violence, although guns have a decidedly urban association in contrast to the historical, even genteel, pedigree of skulls (images of St. Jerome's study or Hamlet's soliloquy come to mind). Yet

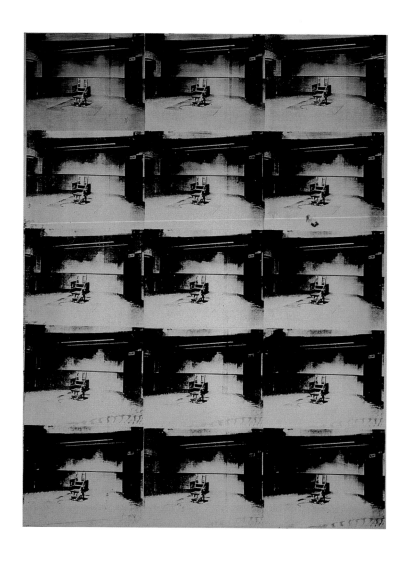

Andy Warhol (American, 1928–1987)

Orange Disaster #5, 1963, acrylic and silkscreen enamel on canvas

106 x 81 ½ inches (269.2 x 207 cm)

Solomon R. Guggenheim Museum, New York, Gift, Harry N. Abrams Family Collection, 1974, FN 74.2118

© The Soloman R. Guggenheim Foundation. Photo by David Heald

despite their confrontational subject matter, guns must also be recognized as familiar social objects, ubiquitous in American culture. In keeping with his practice of selecting something that represents the entire category of objects to which it belongs, Lazzarini chose the Smith & Wesson 38 because it is the archetypal instrument of both law enforcement and criminal activity. Standard issue for most police departments in the United States from the beginning of the twentieth century until the 1980s, when semi-automatics caught on, it is also the number one gun used in crime in this country.[19]

While skulls and guns are overt emblems of death and violence, the specificity that characterizes all of Lazzarini's objects underscores their capacity to remind us of mortality. The very idea of realistic representation—of permanently recording the image of something as it appeared at a particular place and time—engages the notion of death: the fixed representation of a moment that has passed becomes a point of departure from which time marches inexorably forward. (For this reason, photography, one of the most realistic art forms, has long been understood to be about loss and absence as much as about the continuing presence of what is depicted.[20]) In Lazzarini's works, the precision of detail, combined with the faked historicity of weathered and worn surfaces, reminds one of the lifespan of his objects. There is a sense in his works of seeing the passage of time, as if past and future co-exist with the present to animate the static object.

Hand in hand with the specificity of Lazzarini's objects goes the anonymity of the artist. The subordination of individual expression to the authority of the image is common both to Pop Art and to the traditional realism of trompe l'oeil and Dutch still-life painting. Noticeable brushwork, which calls attention to the artist's presence, is eliminated as much as possible. Warhol even embraced commercial processes such as screen-printing as a way to remove his hand from the work (a fascinating decision for one of the most competent and elegant draftsmen of the second half of the twentieth century).

Lazzarini's fidelity to the original object is also meant to remove his presence as a mediating factor between viewer and object.[21] He prefers that the viewer think not about him or his process (technical or intellectual) when looking at the work—despite the autobiographical content mentioned earlier, which can also be understood simply as a way to ground the object further in concrete reality. Rather, he intends the object to be an opaque, self-sufficient thing existing in the world for the viewer to experience independently from any reference to its maker. Lazzarini likens his anonymity to that of a medieval craftsman: the premium placed on technique and execution is meant to give the viewer a more immediate relationship with the work.[22]

This emphasis on confronting the self-sufficient object is also a legacy of one of the most non-referential art movements of the twentieth century, Minimalist sculpture of the 1960s and 1970s. Lazzarini acknowledges, in particular, his interest in the work of Donald Judd, whose highly reduced objects, pared to essential geometries, were understood as rejecting signs of individual subjectivity to focus on "real materials in real space." Lazzarini takes Judd's depersonalized objects further, rejecting also the conventional identification of an artist with his

signature materials, which he sees as outmoded. Lazzarini's statement, "the thing is the thing," tersely summarizes the matter-of-fact quality he achieves by basing his work on the actual materials and actual scale of the original. Its serendipitous echo with a closely related statement—"What you see is what you see"[23]—that Frank Stella made in 1964 when he and Donald Judd were interviewed together underscores Lazzarini's shared embrace of the literal in art. In contrast to his predecessors, however, Lazzarini's emphasis on "thingness" has the ironic effect of making his objects both more actual and more illusionistic.

Minimalism provides several other significant points of departure for Lazzarini's work, as it does for many sculptors today. One is the aesthetic of radical reduction, epitomized by Judd's sleek boxlike constructions (page 43). Made of industrial materials such as plywood, sheet metal, and Plexiglas, Judd's "specific objects," as he preferred to call them, were arranged in strict geometric configurations to eliminate the idea of composition and achieve a singular focus on the object itself. Although embracing extremism, both of realism and distortion, Lazzarini's work similarly pivots on the point of reduction, clarity, and precision. There is nothing extraneous in his pieces. What you see is exactly what existed in the original, only distorted. (The objects he selects tend to have in common a geometric simplicity that reinforces their sense of formal rigor.)

Lazzarini's use of industrial manufacturing processes also owes something to Judd's example, as does his embrace of seriality—the series of incremental variations which, like Warhol, Judd explored extensively but far more systematically, and which forms another important

inspiration for Lazzarini's decision to make the skulls and guns in series of four each. As an artist who mines the overlapping territory between Warhol and Judd, it is not surprising that Lazzarini's favorite works by Judd are the untitled Dia boxes, which he admires not only for their careful use of an ordinary material— Douglas fir plywood—and their unadorned, matter-of-fact form and finish, but also for their funereal quality, set down in their space like rows of pine coffins.

distortion

Perhaps the most significant connection between Lazzarini and Judd involves Minimalism's emphasis on the actual circumstances in which one encounters the work: the phenomenology of viewing. Minimalist objects are resistant, providing no opportunity for absorption of the viewer. There is no point at which the work seems to reveal itself completely or in which viewers transcend their separate position to enter, visually, into the reduced geometric form. Moving around the work yields an inexhaustible supply of new experiences for one to apprehend and compare back to the ideal mental impression of the work's overall form (just as, when encountering the many distorted views of Lazzarini's object, one automatically compares them to a mental picture of the standard form). The specificity of materials, the human scale, and the unity of the object's shape all work together in Minimalist sculpture to insist on the immediate experience of being in the space with, but separate from, the object. [24]

Lazzarini's work shares these qualities. But with his objects, the distortion of form adds another, expressive quality that, coupled with extreme

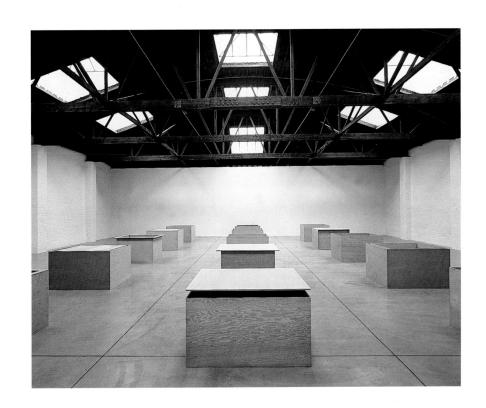

Donald Judd (American, 1928–1994)

Untitled, 1976, douglas-fir plywood

Fifteen boxes, each 3 x 5 x 5 feet (91.4 x 152.4 x 152.4 cm)

Dia Art Foundation

Art © Donald Judd Foundation/Licensed by VAGA, New York, NY

Photo by Stuart Tyson

realism, becomes the central means for heightening viewers' awareness of themselves as subjects. One of the immediate effects of Lazzarini's distortion is to "defamiliarize" objects or make them seem strange. Distortion doesn't negate realism in his work, but it distances us from what we thought we knew.[25] Each piece is a study in contrasts, pulling the viewer between principles of realism and abstraction. By holding these conflicting tendencies in dynamic equilibrium, Lazzarini's work dramatically increases the tension between the real and the representation. One could say that the oscillation between these positions activates the viewer.

El Greco (1541–1614), an artist who worked with distortion as a conscious and fundamental part of his vocabulary, provided one of the most important early sources of inspiration for Lazzarini in his exploration of relationships between realism and distortion.[26] El Greco thoroughly understood naturalistic representation, and the anatomy, poses, and gestures of his figures have a convincing authority (page 45). But he rendered these in shorthand and subordinated the norms of realistic appearance to a different kind of vision. The emotional intensity of El Greco's work reflects the fervor of late sixteenth-century Counter-Reformation Spain, where religious art strove to reinforce belief in Catholic doctrines. In El Greco's charged images, expressive brush strokes are aligned and directional, giving motion to his forms, so that individual masses take on their own movement within the whole. The overall effect is that his figures and the environments they inhabit seem gripped by powerful internal or external forces, serving as potent metaphors for the workings of spirituality.

Although not motivated by spiritual impulses, Lazzarini's works also seem subject to extreme forces. The appearance of internal unrest in El Greco's paintings inspired Lazzarini's sense of his objects as "painterly" gestures, pliable forms whose distortions could convey intense emotional and psychological expression. As Lazzarini's only freestanding piece, *payphone* perhaps provides the most complete experience of internal forces warping a form. The source for *payphone* is the common half-booth, or "walk-up," with light box advertising that was first manufactured in 1976 and became common on New York City streets beginning in the early 1980s. Lazzarini's version retains the Bell Atlantic logo, although the name had changed to Verizon by the time he began fabricating the work. The metal coin box is stamped with the name of Bells' predecessor, Nynex. (This changing of corporate branding, where past and implied future cohabit the present, reinforces Lazzarini's interest in the object as marking the passage of time, as do several other features: on one side an advertisement for DeBeers diamonds, urging a ghostly whisper in the ear of one's beloved; the other side left blank, except for the white glow of fluorescent tubes; and inside a New York Police Department crime alert poster about a stabbing that occurred on Lazzarini's old corner.)

As a work that can be fully experienced in the round, *payphone* would seem to allow for the conventional mode of viewing sculpture: "a mobile observer willing to link idealized profiles of an object into a seamless and harmonious 'cinematic' progression."[27] But *payphone* doesn't deliver; it subverts the impulse toward coherence and cohesion. Each new view provides another confounding and irreconcilable distortion of the

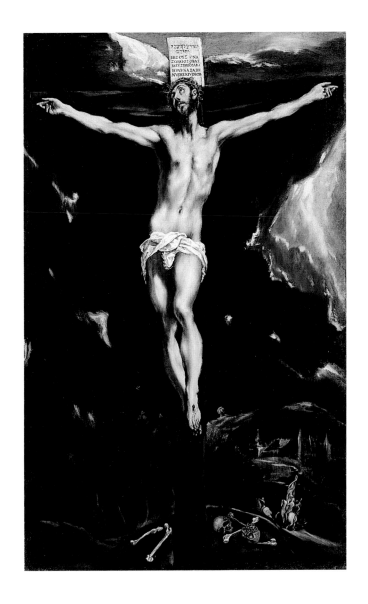

El Greco (Domenico Theotokopoulos; Spanish, born Greece, 1541–1614)

Christ on the Cross, 1600–1610, oil on canvas

32 ½ x 20 ⁵⁄₁₆ inches (82.6 x 51.6 cm)

The J. Paul Getty Museum, 2000.40

Photo by Louis Meluso

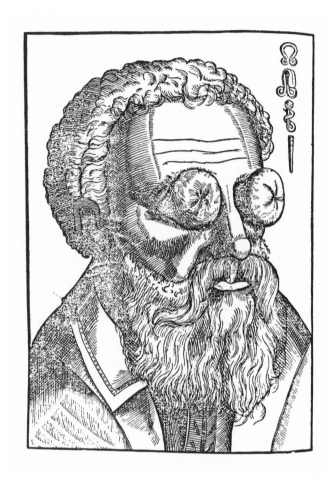

Georg Bartisch (German, 1535 – ca. 1606)

Woodcut from **Opthalmodouleia,** 1583

Dresden

familiar urban object as it seems to accelerate and decelerate, expand and contract with the viewer's changing perspective. Our bodies twist and bend empathetically with the torqued work as we try to find what might be the correct viewing position, and our physical efforts make us acutely aware of ourselves as viewers.[28] While this experience recalls the viewing conditions that Minimalist artists sought for their work, Lazzarini's pieces resist vision more aggressively, giving the impression that the object—far from inert and unresponsive—has agency.

This sense that the work simultaneously attracts and repels our vision by its tension between perfection and distortion makes an interesting comparison with an etching from sixteenth-century German ophthalmologist Georg Bartisch's *Ophthalmodouleia* (1583), the first systematic work on ocular disease and ophthalmic surgery.[29] It was a landmark scientific study, but also very much a work of its time: this image illustrating the effects of ocular fascination (page 46) appeared in a chapter on injuries resulting from "magic and witchcraft, monsters and the work of the devil." It shows a bewitched subject's eyes turned back on themselves, providing a grisly picture of the inversion of the seer and the seen. As one scholar succinctly describes it: "Fascination can solicit and eclipse sight in a single reversionary moment."[30]

vision and death
The way in which Lazzarini's objects simultaneously engage and thwart our vision connects them to a central theme in Western philosophy and visual theory: the relationship between subject and object. A primary issue in modern thought from Descartes to Postmodernism, this relationship concerns how we can know what is outside of ourselves. Given the understanding of sight as the dominant sense in the modern era,[31] this question has often hinged around vision and its relative subjectivity or objectivity. It is in relation to vision that the philosophical concepts of realism and representation collide: to what extent is the world real and to what extent is it a construct?

The Renaissance discovery of mathematically exact perspective in the first decades of the fifteenth century provided artists with a set of rules for creating convincing representations of three-dimensional space on two-dimensional surfaces. Perspective also quickly came to be seen as an objective proposition about the actual structure of perception, not just a formula for constructing pictures. Yet its underlying assumptions were bold abstractions from the subjective experience of vision. The viewer is conceived of as a single, unmoving, and disembodied eye positioned at the origin of a cone of visual rays that measure and systematize space as they radiate out to the objects within it—like the all-seeing God's eye at the apex of the pyramid. The rationalized space that perspective reveals is equally abstract: unified, unchanging, and infinite.[32]

Over the next two centuries, this translation of psychological and physiological awareness of space into a mathematical construct became the visual analogy for scientific and philosophical rationalism. Using his famous method of doubt, Descartes (1591–1650) sought to develop a comprehensive and systematic body of truths, obtaining his knowledge of the nature of existence by reason alone. His *cogito ergo sum* (I think, therefore I am)[33] meant that thinking, as the essence

of being, requires no physical place and depends on no material thing. Pure consciousness is entirely separate from the matter it seeks to know.

Descartes's disembodied subject, knowing the world by its extension of thought, came to be understood as the philosophical counterpart to the single eye at the apex of the cone of vision: both perceive a rational and ordered world of inert matter from which they remain detached, objective observers. Perspective became a philosophical metaphor for the relationship between the individual and the world.[34] In this way, perspective was transformed from a pragmatic invention into something akin to truth, obscuring its contingent and convention-bound nature. Referred to in contemporary visual theory by the shorthand term "Cartesian perspectivalism," this rationalist paradigm of the division between subject and object, mind and matter, dominated Western thought well into the twentieth century.[35]

An object that resists or repels vision, as Lazzarini's works seem to do, can raise serious questions about an ordered and rational worldview. By shaking the certainty of our visual mastery—our assumptions of authority as a subject and our sense that the world is knowable by the faculty of vision—it even reaches to our identity in so far as we define ourselves by the picture of the world that we construct and the way in which we situate ourselves in relation to that picture. The visceral distortion in Lazzarini's work decalibrates vision and decenters the viewer from a fixed observation point, undermining the still lingering notion of the eye as a disembodied tool by which to collect objective information about the external world.

One contemporary theorist central to dismantling the Cartesian model is French psychoanalytic philosopher Jacques Lacan. His theory of the gaze reinstates those human elements that disrupt the conventional model of the subject and object: the body, desire, and the unconscious. In one of his *Seminars* on the subject, Lacan used the image of the distorted skull in Holbein's *The Ambassadors* as a centerpiece for redefining the relationship between the viewer and the world.[36] For Lacan, this curious image gives figural shape to the impossibility of certainty and self-verification through vision.

Lacan understands visuality as a screen existing between observer and observed, a social network of signs where visual meaning is made and into which we are inserted as we "learn" to see. The instability of Holbein's anamorphic image is like a tear in this fabric that draws attention to its existence, betraying its usual invisibility. Consciousness of the network of visual signs brings awareness of the impersonality of vision: contrary to our general impression, visual comprehension is a cultural construct that both precedes and outlasts us as well as transcends our individual participation during our own lifetime. This realization of vision's independence from an individual observer casts what Lacan variously calls a shadow or a stain on our perceptual field—a reminder of our temporal limits. That a skull provides Lacan with the analogy for the decentered subject simply underscores for him the intimate relationship between perception and mortality.

It should not be surprising, then, that Lazzarini's work can deal simultaneously with vision and death, despite the apparent contradiction between

these terms.[37] His objects appear in the process of losing their identity before our eyes, slipping from a highly articulated state toward undifferentiated matter. Their visual uncontrollability suggests something beyond comprehension. (In this sense a distorted skull is an arresting redundancy, the form and image expressing the same state of being, as if the object were dying twice.)[38] Distortion is the means for expressing an acute sense of life's fleeting nature. The specterlike quality of Lazzarini's objects, seemingly in transition between two worlds, gives material presence to deathliness.

Lazzarini's interest, however, is not in death per se. It is in a heightened sensitivity to life that includes keen awareness of mortality as one of its central features. This concern is at the heart of his work. In fact, he considers it to be the reason he makes art, seeking to respond to the feelings aroused in him by certain familiar objects, which, through prolonged consideration, can appear to embody something entirely beyond our grasp. For a body of work so focused on intense optical experiences to be equally concerned with what ultimately exceeds vision is an unusual pairing of interests. The tension his work creates between absolute clarity and the impossibility of fixing the object in one's gaze can be understood as a direct outcome of his creative process: transforming the real into the virtual and then back again. The end result resembles a contemporary version of the sublime, that Romantic notion of an overwhelming but indeterminate sensation filling the mind so completely that it overtakes our faculties of comprehension.[39] Similarly, in Robert Lazzarini's work, intimations of something beyond representation cast their shadows on the visible world, charging the experience of seeing with indescribable fascination.

JOHN B. RAVENAL
Curator of Modern and
Contemporary Art

49

ENDNOTES

1. Lazzarini has used the phrase "objects slipping toward their own demise" in conversation with the author and elsewhere. Other statements attributed to the artist in this essay, and many of the insights into his work, have come from our extensive communication—in person, on the phone, and by e-mail—beginning in early 2002.

2. *Fencing Doublet,* Western European, ca. 1580, leather, silk, linen, cotton, gold and silver yarns, 29.158.175.

3. Antonio Stradivarius (1644–1737), 55.86a.

4. Lazzarini likes the fact that Photoshop—a program for creating and editing images introduced in 1990 for use by graphic designers and photographers—now exists on Macs and PCs around the world. It's a tool at everyone's disposal, although no one has applied it in quite the way he has. There are various ways to construct a virtual object in CAD (computer-aided design and drafting programs first developed in the 1960s for engineering, manufacturing, and architectural applications). Lazzarini uses differing methods depending on the piece. For *phone,* he had the handset and body laser-scanned, while he drew the dial, cord, dial stop, and rubber feet on the computer with three-dimensional modeling software.

5. There are various types of rapid prototyping, some of which are additive processes and some of which are both additive and reductive. Lazzarini tends to use Laminated Object Manufacturing for larger parts and Stereolithography for smaller parts. See http://www.cs.hut.fi/~ado/rp/rp.html for one source of further information.

6. Among artists incorporating overt signs of computer vocabulary in nondigital media, one could cite Carl Fudge, Albert Oehlen, and Pedro Barbeito, among many others.

7. Although not nearly as elaborate as *payphone, phone* was an extremely complex object to produce. Once Lazzarini had cast the phone in green plastic in the so-called master production mold, he realized it needed further refinement to allow the bottom metal plate to fit properly. He went back and carved the cast plastic object, which he then used to make a second master mold in which he recast the final object. Additional steps were required for several other parts. The flattened rubber cord connecting base to handset was cast with a wire inserted through its length to provide extra structure, a fairly sophisticated process for a simple part, and was hand tinted to match the phone. The numbers and letters on the phone's face were created with a combination of software programs, and then fabricated in collaboration with a graphic designer who converted the electronic file to a silk-screened water decal that could be hand-applied piece by piece. The rotary finger wheel was cast in clear plastic following

the refinements of its prototype and plaster models. The small metal dial stop was also made as a rapid prototype followed by a plastic positive, which was sent to a jeweler who cast it in white metal and returned it to Lazzarini for polishing. The bottom metal plate was especially complicated, taking more than four years and many stages of trial and error to arrive at the solution: an aluminum sheet (with acid-etched openings) was pressed over a male mold, basically creating a primitive die press; the finished piece was then anodized.

8. The Hellenistic period is usually divided into a Greek phase (323 B.C.–146 B.C.) and a Greco-Roman phase (146 B.C.–30 B.C.). The Second Empire extended from 1852 to 1870. From this period, Lazzarini cites Jean-Baptiste Carpeaux as a particular influence.

9. Because the *skulls* were Lazzarini's first works to be widely seen, many viewers recognized the formal similarity to the distorted skull in *The Ambassadors.* Lazzarini has studied the Holbein painting (and even considered re-making it as a reverse distortion so that the entire painting would be seen anamorphically except the skull, which would appear as the one normative object). But, as will be discussed later in the essay, the direct influence of this work on his decision to make distorted skulls is minimal.

10. David Topper points out that many scholars have incorrectly described the nature of the anamorphic distortion in *The Ambassadors,* including misstating the position from which the skull should be seen to resolve into recognizable form. See Topper, "On Anamorphosis: Setting Some Things Straight," *Leonardo* 33, no. 2 (2000): 115–24.

11. See *Simulations* (New York: Semiotext(e)/Columbia University Press, 1983), a translation of *Simulacres et Simulations* (Paris: *Galilée,* 1981).

12. See, for example, *Deceptions and Illusions: Five Centuries of Trompe l'Oeil Painting* (Washington, D.C.: National Gallery of Art, 2002).

13. The 500 series was introduced in 1949, in black with a metal dial. Colors and clear plastic finger wheels were added in 1953, and the range of colors was expanded in 1958. This design was licensed to all comers, and was made by numerous companies. Well over 100 models and variations were produced. See http://users.rcn.com/phonestore/we500typ.htm#Colors, http://members.aol.com/recollectn/phones2.htm, http://www.bellsystemmemorial.com/telephones.html.

14. The original concept for *studio objects* included one of Lazzarini's work boots. A prototype, made with stitched and distressed leather, metal eyelets, and a rubber sole

was shown at Pierogi, Brooklyn, in 2000 with the other three objects, but was set aside as incomplete, to be revisited at a later date.

15. "Post-studio" art grew out of 1960s Happenings, Fluxus, Earth Art, and Conceptual Art practices that moved beyond painting, sculpture, and other traditional forms. Some contemporary artists who continue in this vein, making work that can be thought of as "social sculpture," include Rirkrit Tiravanija, Francys Alys, and Cai Guo-Qiang.

16. See John B. Ravenal, *Vanitas: Meditations on Life and Death in Contemporary Art* (Richmond: Virginia Museum of Fine Arts, 2000).

17. Warhol's paintings of guns and knives were shown first with his dollar sign paintings at the Castelli-Goodman-Soloman Gallery in East Hampton, New York, in May–June 1982, and with his cross paintings at the Galerie Fernando Vijande, Madrid, in December 1982–January 1983.

18. Lazzarini's steel and walnut handguns began as part of a series called *Ways of Death,* objects that symbolized the statistically most common forms of unnatural death in the United States: guns, cigarettes, sleeping pills, a Jack Daniels bottle, and a blown-out car tire. Over time, Lazzarini became more interested in "murderous objects"—a shotgun, hatchet, bottle of poison, Smith & Wesson 38, and knife—for their darker and more visceral power of suggestion. Eventually, he reduced the group to just guns and knives in order to explore the variations of each form, to achieve better control of a smaller range of materials, and to focus more sharply on their specific psychology. The guns and knives will first be shown together at Pierogi in Brooklyn, New York, in October 2003; just the guns will be shown in Richmond. The cigarettes became an independent work of two packs, one Marlboro regulars hard pack, one Camel no filters.

19. See Elaine Shannon, "America's Most Wanted Guns: A New ATF Study Reveals the Country's Top 10 Crime Guns," *Time Online Edition,* Friday, July 12, 2002, http://www.time.com/time/nation/article/0,8599, 320383,00.html. It is estimated that nearly six million Smith & Wesson 38s have been produced to date (not counting millions of copies made in places like Spain, France, and Brazil), more than one million of which were carried into World War II by American soldiers. Not particularly powerful or accurate, the Smith & Wesson 38 has nonetheless proven extremely versatile since its appearance in 1899, and current models differ very little from the old-fashioned six-shooter produced a century ago. See http://web.utk.edu/~giles/third.html.

20. See, for example, Roland Barthes, *Camera Lucida: Reflections on Photography,* trans. Richard Howard (New York: Hill and Wang, 1985, fifth printing).

21. Like Barthes' death of the author, this decentering of the artistic subject rejects the model of autobiographical, confessional art, proposing instead that the viewer participates in creating its meaning. See Barthes, "The Death of the Author," *Image, Music, Text,* trans. Stephen Heath (New York: Noonday Press, 1977).

22. Although this popular conception of medieval craftsmen as anonymous in their own time is not without basis, Meyer Schapiro, in "On the Aesthetic Attitude in Romanesque Art" in *Romanesque Art* (New York: George Braziller, 1977), describes a world of innovative artists signing their works, often prominently, in spite of their humble social status. He further describes an attitude to art and artists that begins to resemble the modern: "There's rapture, discrimination, collection; the adoration of the masterpiece and recognition of the great artist personality; the habitual judgment of works without reference to meanings or to use; the acceptance of the beautiful as a field with special laws, values, and even morality" (p. 23).

23. Bruce Glaser, "Questions to Stella and Judd," reprinted in Gregory Battcock, *Minimalism, A Critical Anthology* (New York: E. P. Dutton, 1968), p. 158.

24. In a famous essay from 1967, Michael Fried criticized Minimalist art for what he called its "theatricality," citing just the points that Judd and Robert Morris upheld as confirmation of Minimalism's superiority to other arts. See Fried, "Art and Objecthood," reprinted in Gregory Battcock's *Minimalism,* cited in previous note.

25. "Defamiliarization" has been a central strategy of avant-garde art since the early twentieth century. The word was coined around 1914 by Russian Formalist theorist Viktor Šklovskij, who considered it to be the very purpose of art: to open our eyes and rejuvenate habituated vision. For an introduction to Šklovskij's thought, see Peter Steiner, *Russian Formalism, A Metapoetics* (Ithaca, London: Cornell University Press, 1984).

26. Lazzarini also has a long-standing interest in Medieval and Northern Renaissance art, based on his appreciation for the interplay between naturalism and schematization that occurs there. On a walk through the Metropolitan Museum of Art with the author (14 December 2002), he expressed particular enthusiasm for a number of anonymous carved wood and marble pieces where the competing demands of plasticity and pattern, solidity and flattening, volume and line are made overt. Paintings by Petrus

Christus, Jan van Eyck, Lucas Cranach the Elder, and
Hans Memling elicited similar interest.

27. Daniel L. Collins, "Anamorphosis and the Eccentric
Observer: History, Technique and Current Practice,"
Leonardo 25, no. 2 (1992): 182. See also part one of this
article, "Anamorphosis and the Eccentric Observer:
Inverted Perspective and Construction of the Gaze,"
Leonardo 25, no. 1 (1992): 73–82.

28. For an interesting discussion of the body in extreme
motion, see chapter four, especially pp. 133–40, of James
Elkins, *The Object Stares Back: On the Nature of Seeing*
(San Diego, New York, and London: Harcourt Brace &
Company, 1996).

29. Bartisch lived from 1535 to ca. 1606. The *Ophthalmod-
ouleia* was translated and republished in a facsimile edition
in 1996 by J. P. Wayenborgh Press, Oostende, Belgium,
translated by Donald Blanchard, M.D.

30. Christopher Pye, *The Vanishing: Shakespeare, the Subject,
and Early Modern Culture* (Durham and London: Duke
University Press, 2000), p. 64. The image of ocular
fascination appears on p. 48 of *The Vanishing.*

31. For one of the most comprehensive contemporary treat-
ments of Western visuality see Martin Jay's writings:
"Scopic Regimes of Modernity," in *Vision and Visuality:
Discussion in Contemporary Culture,* ed. Hal Foster (New
York: Dia Art Foundation, 1988) and *Downcast Eyes: The
Denigration of Vision in Twentieth-Century French Thought*
(Berkeley: University of California Press, 1993).

32. There is a vast body of literature on perspective.
The essential text, first published in 1435, is Alberti's
On Painting, trans. John R. Spencer (New Haven and
London: Yale University Press, 1966). There are also
extensive analyses of the critical and philosophical impli-
cations of perspective. For an introduction, see Irwin
Panofsky, *Perspective as Symbolic Form,* trans. Christopher
S. Wood (New York: Zone Books, 1991) and essays by
Martin Jay, Jonathan Crary, and Norman Bryson in
Foster, ed., *Vision and Visuality,* see note 31 above; also
Crary, *Techniques of the Observer* (Cambridge and London:
MIT Press, 1990); Bryson, *Vision and Painting: The Logic
of the Gaze* (New Haven and London: Yale University
Press, 1983); and James Elkins, *The Poetics of Perspective*
(Ithaca and London: Cornell University Press, 1993).

33. René Descartes, *Meditations,* 1641.

34. Jen Boyle notes that Leibniz was the first philosopher
to use this analogy consciously. See "The Anamorphic
Imagination and the Empirical Body: Perspective and the
Embodiment of Space and Text in Restoration and Early
Eighteenth-Century Science," unpublished paper in the
Department of English and Comparative Literature,
University of California, Irvine, www.ags.uci.edu/
~jeboyle/projectcontext.html, page 6 and footnote 6.

35. It is currently a debated subject whether perspective
directly influenced Descartes in his search for ontological
and epistemological certainty or whether the comparison
between visual and philosophical systems is a modern
retrospective enterprise. In addition to the texts cited
above in notes 27, 31, 32, and 34, see Lyle Massey,
"Anamorphosis through Descartes or Perspective Gone
Awry," *Renaissance Quarterly* 50, no. 4 (Winter 1997):
1148–89. Moreover, despite what appears to be Cartesian
perspectivalism's dominance over half a millennium of
Western thought and art, alternative models of vision
existed. Martin Jay describes how other methods of rep-
resentation arose that did not rely on linear perspective.
Interestingly, Lazzarini's work, which is so closely con-
nected to perspective by its mathematical distortions of
two-dimensional images in Photoshop, relates equally
closely to both of the primary alternatives.

One model, discussed earlier in relation to his work,
is seventeenth-century Dutch still-life painting. Jay notes
that art historian Svetlana Alpers characterizes this mode
as "the art of describing" for its emphasis on representing
surface detail and its faith in material solidity, traits very
much in keeping with Lazzarini's exacting re-creation
of visual and tactile surface detail. The other alternative
is the Baroque, which embraces excess and "madness"
of vision over the logic and restraint of perspective.
I've discussed Lazzarini's work in light of excess, both
of realism and of distortion, and I believe the disruption
it creates in "normal vision" can be fruitfully related to
the Baroque model, as I began to do with El Greco. In
further defining the Baroque as a visual style more than
as a specific historical period, Jay offers additional charac-
teristics, all applicable to Lazzarini's work: dazzling, dis-
orienting, excessive, opaque, unreadable, indecipherable,
distorted, reveling in contradictions, revealing the con-
ventional nature of normal vision, and touching on the
sublime and melancholy.

It is interesting, also, to note that Lazzarini's interest in
historical realist sculpture, as described earlier in the essay,
tends toward the most baroque examples: Hellenistic art
with its anti-classical interest in extreme emotional and
physical states, as evidenced in one of the best known
Hellenistic sculptures, the Laocoön (which, not coinciden-
tally, is the subject of El Greco's only surviving mythologi-
cal painting); and Carpeaux, who is perhaps the most
baroque of Second Empire sculptors, sharing the Hellenistic
emphasis on extreme physical and psychological states

of expression (he also found the Laocoön of immense inspiration for his own work.)

36. Jacques Lacan, *The Four Fundamental Concepts of Psychoanalysis,* trans. Alan Sheridan, ed. Jacques-Alain Miller (New York: W.W. Norton & Company, 1998). Also see Bryson, *Vision and Painting,* note 32 above. It is interesting, in this light, to think of Lazzarini's early angled slide projections—homemade anamorphic distortions—which played a formative role in his work, and which therefore linked vision and death in his work from its beginning.

37. For a fascinating discussion of seeing and representing death, see pages 107–15 in James Elkins, *The Object Stares Back,* note 28 above. Elkins notes that one can identify the moment before death and the moment afterwards, but at which precise moment death is actually present is much more difficult to determine.

38. This interest in "self-awareness" also guided Lazzarini in choosing three images of skeletons for a not-yet-completed set of woodblock prints based on Andreas Vesalius's famous sixteenth-century anatomical study, *De Humani Corporis Fabrica.* One skeleton is shown contemplating a skull; another is weeping over its own death; a third skeleton is digging its own grave.

39. The early and primary proponent of the sublime, English philosopher Edmund Burke, defined it as "that state of the soul in which all its motions are suspended, with some degree of horror," and further: "In this case the mind is so entirely filled with its object, that it cannot entertain any other, nor by consequence reason on that object which employs it." *A Philosophical Enquiry into the Origin of Our Ideas of the Sublime and Beautiful,* ed. Adam Phillips (Oxford: Oxford University Press, 1990), p. 53.

AFTERWORD

With our long-standing commitment to contemporary art, the VMFA welcomes the opportunity to present Robert Lazzarini's profound and startling work in this extraordinary book, as well as in the artist's first one-person museum exhibition.

We would like to think that this Richmond presentation is made even more profound by the encyclopedic nature of our permanent collection: spanning over 5,000 years of world art, it provides a rich context for the work of a very contemporary artist whose creativity has been nourished by the artistic achievements of the past. Moments like these argue most eloquently, I believe, for the importance of 'general' art museums such as the VMFA that maintain a strong commitment to contemporary art and artists. By having the opportunity to work closely with Lazzarini on the design of the book and exhibition, the VMFA is able to expand the relationship between artist and viewer and enhance the experience of art for all.

In reading the thoughtful essay by John Ravenal, curator of the exhibition, we come to a greater appreciation of each sculpture as both a technical tour de force and a vehicle for multiple meanings. Lazzarini uses familiar, everyday objects that in themselves have the potential to set off a range of associations for individual viewers. Taken together, they also form the basis for a meditation on such timeless themes as the nature of reality and the meaning of death. It is heartening to encounter a contemporary artist who provides an experience that is both challenging and accessible. It is a privilege for an art museum and its staff to share such work with the public.

We are especially grateful to John Ravenal for setting in motion a dynamic collaboration between artist, curator, and museum staff, all of whom worked tirelessly to make sure that their joint vision was realized in every detail. They were supported in their efforts by a large group of donors, including The Council of the Virginia Museum of Fine Arts, The Evans Exhibitions Endowment, The Horace W. Goldsmith Foundation, and The Peter Norton Family Foundation. They all deserve our thanks, especially for their generosity in difficult economic times. We would also like to thank the Whitney Museum of American Art for making possible the loan of *payphone* to this exhibition.

Finally, I would like to thank Robert Lazzarini for sharing with us in his exhibition not only some of his greatest work of the past few years but also some of his newest work—so new, in fact, that the series of four steel and walnut guns was still in production at the time of this book's publication. The exhibition also includes a number of drawings that further demonstrate the breadth of Lazzarini's artistic intent.

MICHAEL BRAND
Director

SPONSORS

The Museum gratefully recognizes generous
gifts from

The Council of the Virginia Museum of Fine Arts
The Fabergé Ball Endowment
The Horace W. Goldsmith Foundation
The Peter Norton Family Foundation

Page and Sandy Bond
Ann and Bob Burrus
Janice and Mickey Cartin
The Community Foundation
Coplon's
CSX
Julia and John Curtis
Kay and Philip Davidson
Hugh and Susan Ewing
Anna and Fleet Garner
Janet and Jonathan Geldzahler
Agnes Gund and Daniel Shapiro
Fredrika and Paul Jacobs
Natalie and Robert Kincaid
Frances Lewis
Robert Lehman Foundation
Steve Markel
Ivor and Annegret Massey
Sara and Paul Monroe
Knut Osland
The Ravenal Foundation
Kathleen and Bagley Reid
Bev and David Reynolds
Toni A. Ritzenberg
Stanley and Nancy Singer
Jennifer and Geoff Sisk
Carolyn and John Snow
Marion Boulton Stroud
Deborah and Thomas Valentine
Three Donors Who Wish to Remain Anonymous

ACKNOWLEDGMENTS

My interest in Robert Lazzarini's work began with seeing his vertigo-inducing installation of skulls in the Whitney Museum's *BitStreams* in 2001. For me, as for many, these were the most memorable pieces in that timely exhibition about the impact of digital technology on contemporary art. A follow-up studio visit confirmed the visual and emotional power of his complex sculptures and helped reveal the broader spectrum of issues they address. Organizing a solo museum exhibition and monographic publication seemed the perfect opportunity to bring his body of work together for the first time and to share my enthusiasm for it with the public. It has been tremendously rewarding to study Robert's art and to work closely with him on its presentation. His energy; his generosity with time, information, and insights; and his eye for detail and concern for precision have all contributed immeasurably to this undertaking. I believe I speak for everyone at the Museum with whom he had contact that his active participation not only ensured a better end result but afforded a profound level of enjoyment and education in the process.

We are fortunate in having the support of a large and impressive group of donors for this project, both nationally and in Virginia. To these individuals, foundations, and corporations, each acknowledged by name on page 55, I owe my deepest appreciation. Particular thanks are due to Page Bond for her special efforts on behalf of the Museum.

For valuable assistance with the exhibition and publication I am grateful to the Pierogi Gallery, in particular Joe Amrhein, and to my colleagues Christopher Pye, Larry Rinder, and Waqas Wajahat. Thanks are also due to The Whitney Museum of American Art for generously facilitating the loan of *payphone*.

At the Virginia Museum of Fine Arts, I extend special thanks to Michael Brand, Director, whose enthusiasm for this project and support for contemporary art programs are deeply appreciated. Unwavering support from Carol Amato, Chief Operating Officer, and encouragement from Joseph Dye, Chief Curator, were also essential to the success of the project. Sound guidance from Kathleen M. Morris, Associate Director for Exhibitions and Collections Management; Carol Moon, former Exhibitions Manager; and Aiesha Halstead also played a central part. David Noyes and his team, including Michelle Edmonds, helped develop a sophisticated exhibition design, the execution of which Mary Brogan so efficiently managed. Mary and her team also deserve thanks for a complex lighting program. Appreciation also goes to Bob Frances and his team for constructing galleries within galleries.

For a stunning publication, I am indebted to our Chief Graphic Designer, Sarah Lavicka, who collaborated closely with Robert on the design, and to Rosalie West, Editor in Chief, for her usual care and thoroughness. Sara Johnson-Ward deserves recognition for her publication marketing efforts, Suzanne Freeman for her many varied efforts on behalf of the book, and Anne Adkins for editorial assistance. Karen Daly gracefully coordinated the movement and handling of the objects, and Roy Thompson, Randy Wilkinson, Andy Kovach, and Geoff Strong

ably installed them. Interns Ginger Cofield and Laura Gilmour provided valuable research assistance. In Development and Membership, Pete Wagner, Sharon Casale, Elizabeth Lowsley-Williams, and Margaret Wade made important contributions. I also appreciate the efforts of Michael Smith, Suzanne Hall, Don Dale, and Suzanna Fields in Public Relations and Ron Epps in Education and Outreach.

As ever, I offer gratitude to Virginia Pye, and to Eva and Daniel, for their tolerance and goodwill.

JBR

It is such a tremendous honor to have the support of an institution of the caliber of the Virginia Museum of Fine Arts. I would like to extend my deepest gratitude to Director Michael Brand for presenting this exhibition of my work in such a generous manner.

It has been my great privilege to work with John Ravenal, whose graciousness, integrity, scholarship, professionalism, and insight have graced this project immensely. I am grateful for our many discussions on a broad range of topics and his exceptional ability to reveal the meaningful, the hidden, and the profound.

I want to acknowledge the attentive hard work and warm hospitality of the entire museum staff, especially Carol Moon, David Noyes, Michelle Edmonds, Mary Brogan, Sarah Lavicka, Rosalie West, Sara Johnson-Ward, Suzanne Freeman, Karen Daly, and Suzanne Hall.

I am greatly indebted to all of the donors to this exhibition for their extreme generosity and support. I wish to extend a special thanks to Peter Norton and the Peter Norton Family Foundation.

Thanks to Joe Amhrein, Susan Swenson, and Larry Rinder for an enduring confidence in my work; Ada Chisholm at Pierogi for her daily assistance; Felicia Isabella for her hard work and dedication in the studio; my dear friends Max Mayhew, Daniel Carello, Marybeth Schmitt, Jennifer Olshin, and Leslie Cohan for their kind guidance and support.

My deepest thanks to Lauren Ross for her intelligent counsel and caring insight and to my parents, Alice and Bob Lazzarini, who have always provided the support I needed to follow my heart.

RL

CHECKLIST

Height precedes width followed by depth.

violin, 1997 PAGES 4–7
Flame maple, ebony, bone, and spruce
19 x 30 $\frac{1}{2}$ x 12 inches
Edition of three plus one artist's copy

hammers, 2000 PAGES 8–9
Oak, steel
Two objects, 13 $\frac{1}{2}$ x 16 x 12 inches overall
Edition of ten plus one artist's copy

phone, 2000 PAGES 10–11
Plastic, metal, rubber, and paper
4 x 18 $\frac{1}{2}$ x 7 inches
Edition of six plus one artist's copy

chair, 2000 PAGES 12–15
Maple, pigment
54 x 26 x 12 inches
Edition of six plus one artist's copy

skull (i), 2000 PAGES 16–17
Resin, bone, and pigment
10 x 9 x 6 inches
Edition of six plus two artist's copies

skull (ii), 2000 PAGES 20–23
Resin, bone, and pigment
19 x 3 x 4 inches
Edition of six plus two artist's copies

skull (iii), 2000 PAGES 24–25
Resin, bone, and pigment
4 x 14 x 6 inches
Edition of six plus two artist's copies

skull (iv), 2000 PAGES 18–19
Resin, bone, and pigment
2 $\frac{1}{2}$ x 19 x 3 $\frac{1}{2}$ inches
Edition of six plus two artist's copies

payphone, 2002 PAGES 26–29
Anodized aluminum, stainless steel, Plexiglas,
and silk-screened graphics
108 x 84 x 56 inches
Edition of three plus one artist's copy

BIOGRAPHY

EDUCATION

1985 Parsons School of Design, New York

1990 B.F.A., School of Visual Arts, New York

GRANTS AND AWARDS

1985 Visual Arts Grant, New York Foundation
 for the Arts, New York

1986 Visual Arts Grant, New York Foundation
 for the Arts, New York

2003 American Academy of Arts & Letters,
 Academy Award in Art, New York

EXHIBITION HISTORY

One-Person Exhibitions

1995 Gina Fiore Salon, New York
 September 16–October 12

1998 *Violin,* Pierogi, Brooklyn, New York
 February 13–March 13

2000 *New Sculpture,* Pierogi, Brooklyn,
 New York, October 13–November 13

2003 Pierogi, Brooklyn, New York
 October 10–November 10

Selected Group Exhibitions

1997 *Genuine Fiction,* W-139
 Amsterdam, The Netherlands
 January 17–February 16

 Current Undercurrent: Working in Brooklyn
 Brooklyn Museum of Art, New York
 July 24, 1997–January 25, 1998

 New York Drawers,
 Gasworks Gallery, London, England
 August 29–September 28
 Corner House, Manchester, England
 October 4–November 16

1998 *Invitational '98,* Stefan Stux Gallery
 New York, June 10–July 12

2000 *Multiple Sensations,* Yerba Buena Center
 for the Arts, San Francisco, California
 August 5–October 22

 Haulin' Ass, POST, Los Angeles,
 California, November 18–December 23

 minutiae, Southeastern Center for
 Contemporary Art, Winston-Salem,
 North Carolina, October 21, 2000–
 January 12, 2001

2001 *Pierogi Flat Files,* H&R Block Artspace
 Kansas City, Missouri, January 19–
 February 28

 BitStreams, Whitney Museum of American
 Art, New York, March 22–June 10

 Summer 2001 Group Show, Brent Sikkema
 New York, June 16–July 20

2002 *Situated Realities: Where Technology and
 Imagination Intersect,* Maryland Institute
 College of Art, Baltimore, Maryland
 February 1–March 17

 On Perspective, Gallery Faurschou, Copen-
 hagen, Denmark, January 31–April 20

 The Whitney Biennial, The Whitney
 Museum of American Art, New York
 March 7–May 26

 *2002 Media Art, Daejeon-New York: Special
 Effects,* Daejeon Municipal Museum
 Daejeon, Korea, May 24–July 7

 Media-City Seoul 2002, Seoul Museum of
 Art, Korea, September 26–November 24

2003 *NOWN,* Wood Street Galleries, Pittsburgh,
 Pennsylvania, January 24–March 8

 Back in Black, Cohan Leslie and Browne
 New York, June 26–August 16

BIBLIOGRAPHY

"Adding Extra to Ordinary." *Winston-Salem Journal,* January 7, 2001.

Atkins, Robert. "Surface Pleasures." *artbyte 4,* no.4 (May–June 2001): 66.

Aukeman, Anastasia. "Small Budgets, Large Ambitions." In "Special: The Cutting Edge." *ARTnews* 95 (Annual 1996): 48–54.

Bischoff, Dan. "Moving Images: At the Whitney Biennial, everything — even the façade — is in motion." *The Star-Ledger,* March 7, 2002, 65.

Bodow, Steve. "The Whitney's Digital Sampler." *New York Magazine* 34, no. 12 (March 26, 2001): 72–77.

Budick, Ariella. "Modern Media Blitz." *Newsday,* March 10, 2002, D10.

_____. "How Stars Are Born." *Newsday,* June 9, 2002, D18.

Carvahlo, Denise. "BitStreams." *Flash Art* 34, no. 218 (May–June 2001): 95.

Clifford, Katie. "BitStreams." *ARTnews* 100 (June 2001): 127.

Danto, Arthur C., et al. "New York, November 8, 2001: A Conversation." *tema celeste* 89 (January/ February 2002): 34–39 (illustration only).

Dawson, Jessica. "In Computer-Enhanced Pics, Gee Whiz Overwhelms the Art." *The Washington Post,* March 7, 2002, C5.

_____. "In Baltimore, Buttressing the Case for Art's Tech Support." *The Washington Post,* December 29, 2002, G4.

Diamond, Sara. "Media-City Seoul." *Flash Art* 35, no. 227 (November/December 2002): 99 (illustration only).

Edelman, Robert. "Robert Lazzarini." *Cover* 10, no. 2 (March 1996): 51.

"Everything Old Is New Again at Media Biennale." *Korea Times,* October 21, 2002.

Gardner, Lee. "Brave New World of Digital Imaging Wears a Traditional Face Too." *The Baltimore City Paper,* February 6–12, 2002.

Giovannotti, Michael. "BitStreams." *tema celeste* 85 (May/June 2001): 102.

Griffin, Tim. "The End of the Beginning." *Time Out NY,* no. 292 (April 26–May 3, 2001): 61.

_____. "Bi American." *Time Out NY,* no. 337 (March 14–21, 2002): 81.

Henry, Max. "Robert Lazzarini." *tema celeste* 83 (January/February 2001).

Johnson, Ken. "So Here's the Concept: Copy a Whole Collection." *The New York Times,* February 28, 2003, E46.

Kimmelman, Michael. "Creativity, Digitally Re-mastered." *The New York Times,* March 23, 2001, E31, E36.

Koeppel, Fredric. "Esoteric, We Expect; Emotion, We Prize; New York Art Shows Poles Apart in Relevancy, Poignancy." *The Commercial Appeal,* May 12, 2002, G1.

Krauss, Nicole. "Still Life with Phone and Gun." *ARTnews* 100 (June 2001): 127.

Laster, Paul. Interview. "Robert Lazzarini and Paul Laster." *artkrush the art magazine online,* December 12, 2002. http://www.artkrush.com/eyeto-eye/014_robertlazzarini/index.asp.

Lewis, Richard, and James Luciana. *Digital Media: An Introduction.* Upper Saddle River, New Jersey: Prentice-Hall, 2003.

Muro, Matt. "Pick of the Week." *The New York Times on the Web,* October 19, 2000.

"News and Around." *tema celeste* 84 (March/April 2001): 116.

Paul, Christiane. *Digital Art.* London: Thames & Hudson, 2003.

Phillips, Glenn R. "BitStreams." *Inter Vista* 4, no. 24 (Fall/Winter 2000–2001): 23–27.

Plagens, Peter. "BitStreams." *Artforum International* 39, no. 8 (April 2001): 38.

Pollack, Barbara. "Back to the Future with 'BitStreams.'" *Art in America* 89 (September 2001): 60–63.

"Preview." *artbyte* 3, no. 5 (January/February 2001): 13 (illustration only).

Princenthal, Nancy. "Whither the Whitney Biennial?" *Art in America,* no. 90 (June 2002): 48–53.

Rhee, Wonil, ed. *Media City_Seoul 2002.* Seoul, Korea: Seoul Museum of Art, 2002.

Rinder, Lawrence, and Bahk Jun-goo. *2002 Media Art, Daejeon-New York, Special Effects.* Daejeon, Korea: Daejeon Municipal Museum of Art, 2002.

Rinder, Lawrence, et al. *Whitney Biennial 2002.* New York: Whitney Museum of American Art, 2002.

Rosenbaum, Lee. "Tech Art: Boom or Bust?" *The Wall Street Journal,* April 6, 2001, W14.

Saltz, Jerry. "American Bland Stand." *The Village Voice,* March 7, 2002, 71.

_____. "Byte Lite." *The Village Voice,* May 1, 2001, 71.

Schjeldahl, Peter. "Do It Yourself." *The New Yorker* 78 (March 25, 2002): 98–99.

Smith, Roberta. "Bad News For Art, However You Define It." *The New York Times,* March 31, 2002, sec. 2, 1, 33.

Solomon, Deborah. "Tastemaker, New in Town, Dives into a Caldron." *The New York Times,* May 2, 2001, H1, 9.

Stevens, Mark. "Geek Art." *New York Magazine* 34, no. 13 (April 2, 2001): 69–70.

_____. "Irony Lives." *New York Magazine* 35, no. 9 (March 18, 2002): 55–56.

Trainor, James. "Whitney Biennial." *tema celeste* 91 (May/June 2002): 108–9.

Vogel, Carol. "Inside Art: The Whitney Buys." *The New York Times,* May 4, 2001, E2, E30.

_____. "Inside Art: Betting on Future Stars." *The New York Times,* June 28, 2002, E2, 32.

Zita, Carmen. "In Sight (20 Artists on the Rise)." *TRACE,* no. 36 (February/March 2002): 50–69.

INDEX